TABLE OF CONTENTS

FOLLOW
THE
DREAM
YOU
HAVE
IN YOUR
HEART

IF YOU OPEN YOUR HEART TO POSSIBILITY YOU'LL BE AMAZED AT WHAT YOU DISCOVER

FIND A QUIET
MOMENT
EACH DAY
TO RENEW YOUR
SENSE OF WONDER.

Celebrate
·LIFE·GROWTH·
POSSIBILITY

IT TAKES
LOVE
TO MAKE
A HOUSE
A HOME

These are some of the first illustrations I did when I started incorporating patterning into my work. The illustrations on page 4 are scans of the original 3 ½" x 3 ½" pieces; the ones on this page are scans of two (or more) pieces of art which were composed digitally. One advantage of working both digitally and by hand, is that it allows me to letter my text at a larger size so I have better control of the letterforms, then scan, reduce and place it in the artwork.

THE CREATIVE PROCESS

STEP 1: Draw a shape. Here is a flower as an example.

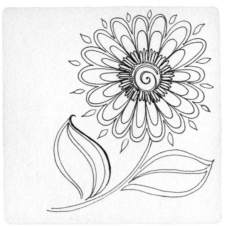

STEP 2: Add a small space around the edge of the shape.

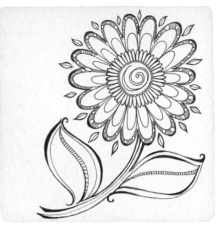

STEP 3: Add pattern inside the spaces.

COLORIZATION OPTIONS

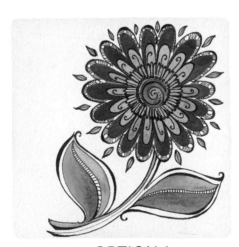

OPTION A:
An original drawing that was hand painted with watercolors.

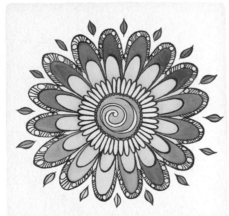

OPTION B:
Scan of original drawing, cleaned in Photoshop, then printed on watercolor paper and hand painted in watercolors.

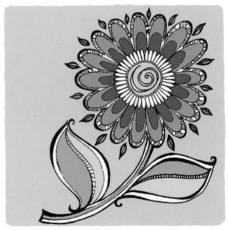

OPTION C:
Scan of original drawing cleaned and colored digitally in Photoshop.

BASIC MATERIALS

One of the nice things about patterning is that it doesn't require a lot of expensive art supplies. All you really need is a pen, a piece of paper and your imagination! Many artists, myself included, are particular about the supplies they use. My favorite pens for patterning work are Pigma Micron® pens by Sakura of America. They are available at most art supply stores and craft retailers. I do most of my work with an 01 size Micron, but if I want a heavier line weight I'll choose the 05 or 08 size. I like Microns because the rich, black ink flows nicely without skipping. It is permanent and archival, and the pen tip allows me to easily build up my line weight by double and triple stroking.

MICRON 005 .20 mm
MICRON 01 .25 mm
MICRON 02 .30 mm
MICRON 03 .35 mm
MICRON 05 .45 mm
MICRON 08 .50 mm

For paper I use Strathmore® 400 Series drawing paper, which is widely available, or the Zentangle tiles which are available at www.zentangle.com. While the patterning techniques can be done with any pen on any piece of paper, using quality art supplies (like Microns and Strathmore paper) makes a big difference to how my work looks — and greatly enhances my enjoyment of the creative process.

Basic Patterns

Patterning is fun, easy and relaxing — and it's a great way to add interest and texture to your designs. The nice thing about patterning is that patterns don't need to be perfect, just rhythmic. In fact most patterns are more interesting when they have subtle variations. Start by drawing a series of horizontal lines. The lines don't need to be totally straight or evenly spaced. Some patterns, like the Fan pattern and the Four Lines & a Circle pattern, work better in small spaces. Others, like the Arch and Triangle patterns, are more effective in slightly larger spaces. By drawing lines different distances apart you'll create some narrower spaces and some wider spaces in which to pattern, as in the example below.

After drawing your lines, look at the step-by-step examples on the next page. Pick the one you want to do and start by drawing step one of that pattern between two lines. The illustration below shows step one of the "Four Lines & a Circle" pattern, also shown at the top of the next page.

Next, starting at the beginning of the line, draw step two on top of step one as shown below.

Then draw step three on top of step two as shown below.

Repeat this process for as many steps as you choose. Patterning is cumulative; each step adds detail to the previous step, and each one can be used as a stand-alone pattern. If you want a simple pattern, stop after one or two steps; if you want a very detailed pattern, keep adding steps. The more steps you do, the more complicated and impressive your finished piece will look!

SEVEN PATTERNS: STEP BY STEP EXAMPLES

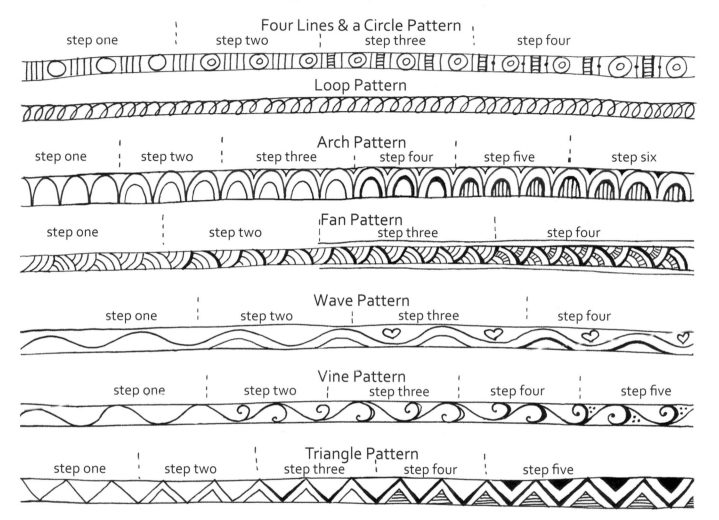

Four Lines & a Circle Pattern
step one | step two | step three | step four

Loop Pattern

Arch Pattern
step one | step two | step three | step four | step five | step six

Fan Pattern
step one | step two | step three | step four

Wave Pattern
step one | step two | step three | step four

Vine Pattern
step one | step two | step three | step four | step five

Triangle Pattern
step one | step two | step three | step four | step five

TRIANGLE PATTERN VARIATIONS

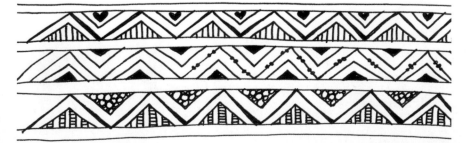

There are many ways to decorate a simple triangle pattern; here are some examples. I encourage you to experiment and try creating new patterns all your own.

FILLER PATTERNS

Patterning dates back to ancient times. Medieval manuscripts are replete with patterns comprised of lines, dots and other small fillers. Try some of these designs, or create your own filler patterns.

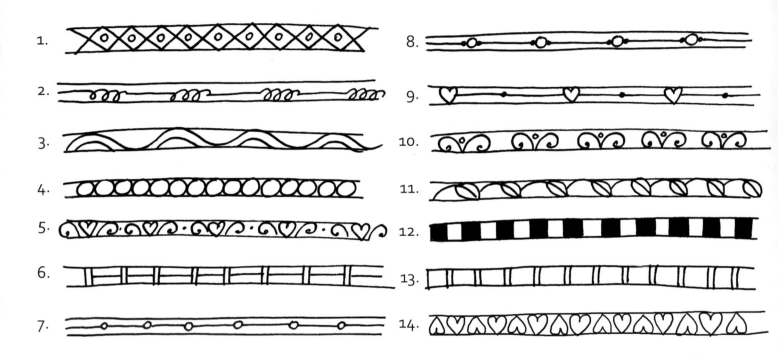

FREE FORM FILLER PATTERNS

A free form filler pattern, like the purple lines below, can be used to even out an irregular space.

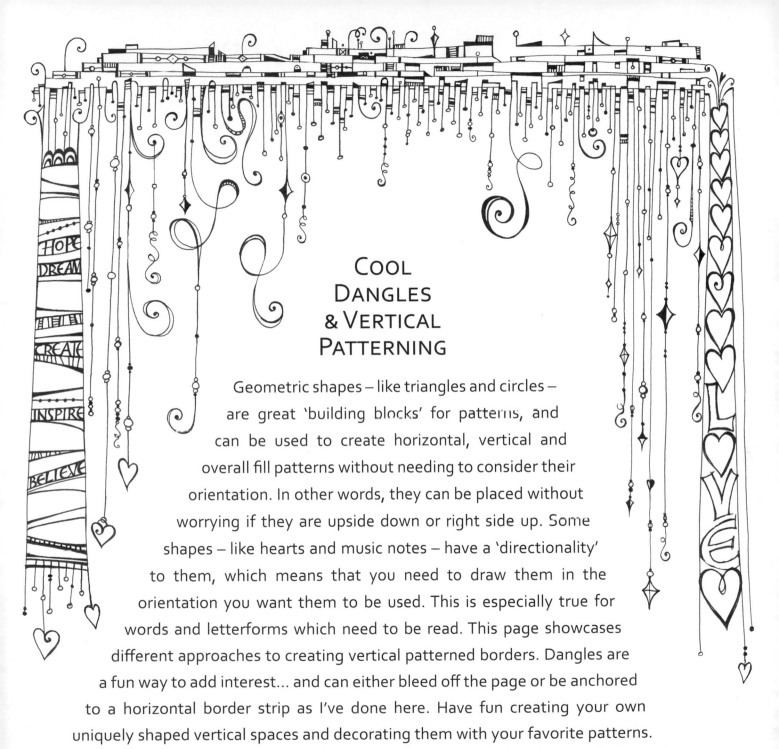

Cool Dangles & Vertical Patterning

Geometric shapes – like triangles and circles – are great 'building blocks' for patterns, and can be used to create horizontal, vertical and overall fill patterns without needing to consider their orientation. In other words, they can be placed without worrying if they are upside down or right side up. Some shapes – like hearts and music notes – have a 'directionality' to them, which means that you need to draw them in the orientation you want them to be used. This is especially true for words and letterforms which need to be read. This page showcases different approaches to creating vertical patterned borders. Dangles are a fun way to add interest... and can either bleed off the page or be anchored to a horizontal border strip as I've done here. Have fun creating your own uniquely shaped vertical spaces and decorating them with your favorite patterns.

PATTERN CIRCLES

Look closely at the example below to see how the patterns evolve. Each additional step adds dimension and complexity to the design.

STEP 1

STEP 2

STEP 3

STEP 4

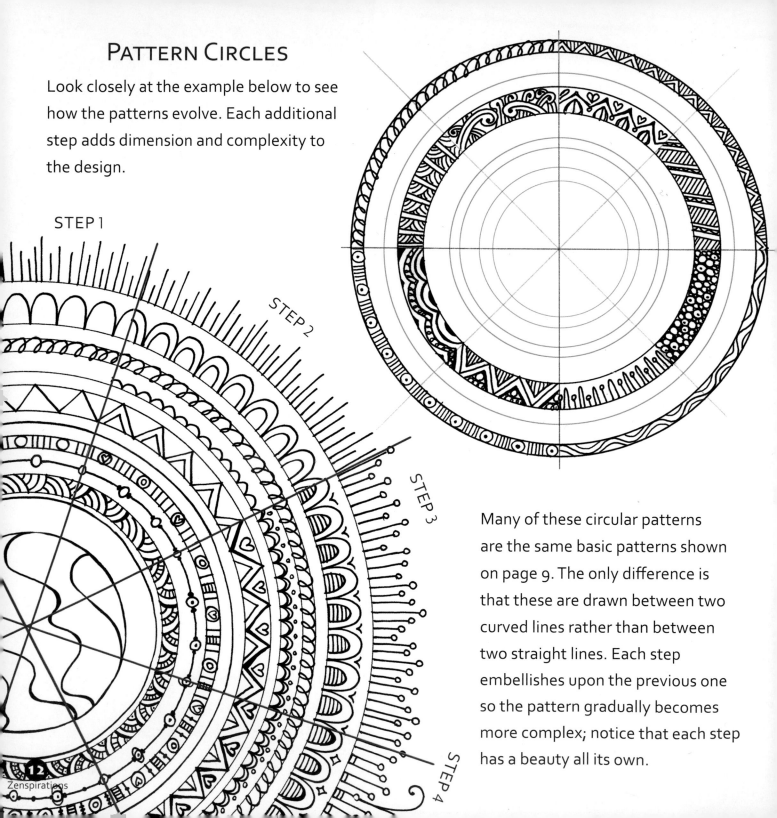

Many of these circular patterns are the same basic patterns shown on page 9. The only difference is that these are drawn between two curved lines rather than between two straight lines. Each step embellishes upon the previous one so the pattern gradually becomes more complex; notice that each step has a beauty all its own.

LEAF CIRCLE

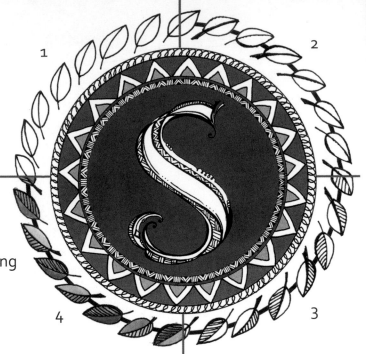

STEP 1 Draw a simple leaf shape, and repeat it around the circle.

STEP 2 Add interest to the leaves by adding weight to the stem and edges; make the design more cohesive by connecting the leaves with a center line.

STEP 3 Add small, tightly spaced lines on alternating sides of the leaves.

STEP 4 Color the leaves as a finishing touch.

TIPS FOR SUCCESSFUL CIRCLE PATTERNS:

One of the things I like best about patterning is that patterns don't have to be perfect. Although there aren't really any rules for patterning (other than to have fun!), here are some helpful tips to keep in mind when patterning around a circle.

TIP 1: Try to create a regular repetition in order to give your patterns rhythmic appeal

TIP 2: Come up with a shape, or a combination of shapes, then repeat and embellish them.

TIP 3: If you want your circles to be even, use a compass or the computer to create them.

TIP 4: It can be helpful to add lines that bisect your circles at even intervals.

TIP 5: If you want to create a complete circular frame quickly, try patterning 1/4 or 1/2 of the circle and then step and repeat the design digitally to create complete circular frames. This is the technique I used to create the patterns framing the letter "S" above.

SIMPLE CIRCLE DESIGNS

Create dazzling drawings that go from an ordinary circle to a detailed drawing in five easy steps! As you'll see with the examples below, starting a design with a central circle is a great way to create unique illustrations. By continuing to add layers of pattern, these illustrations evolve quickly from simple shapes to decoratively detailed illustrations.

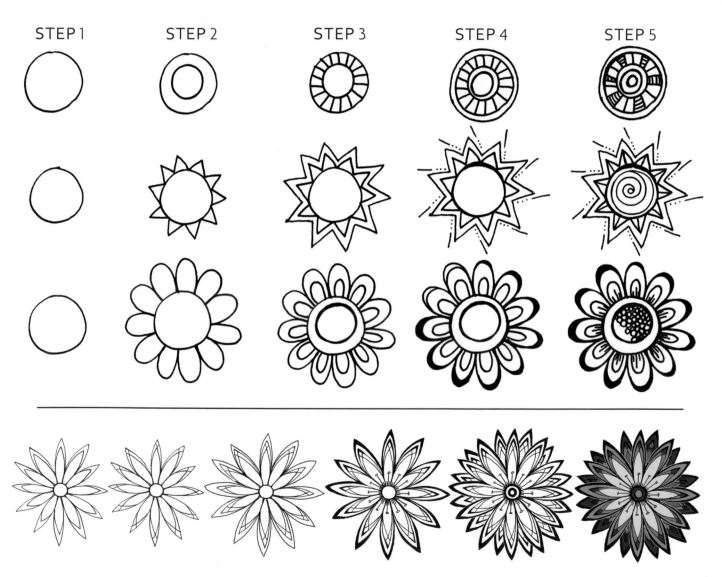

STEP 1 STEP 2 STEP 3 STEP 4 STEP 5

Simple Flower Designs

An easy way to create beautiful flowers is to start with a circle, and then add petals all around it. My two favorite types of petals to draw are pointed petals and rounded petals. As you can see from the examples below, by changing the length of the petals you can create a variety of looks.

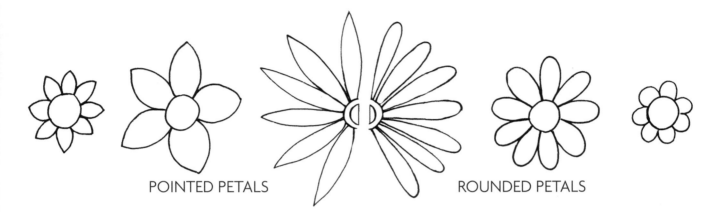

POINTED PETALS ROUNDED PETALS

STACKED PETALS

Once you have the basic petal shapes mastered, try layering them on top of one another as in the four examples of stacked petals on the left. Then experiment drawing the additional shapes below.

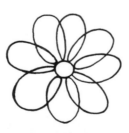
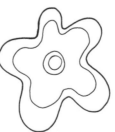
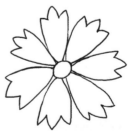

Wedge Petals Heart Petals Loop Petals Free Form Petals Fringe Petals

Patterning in a Wave

Wave patterns are extremely expressive, and will add interest to any journal or scrapbook page. Start by drawing a series of serpentine-like lines, spaced at different intervals from one another, like those shown in the illustration below. Don't try to make the lines parallel to each other — allow them to curve naturally in different places. Patterning is much more interesting when it is organic. Experiment with the basic patterns we learned earlier, and then try to create your own unique patterns.

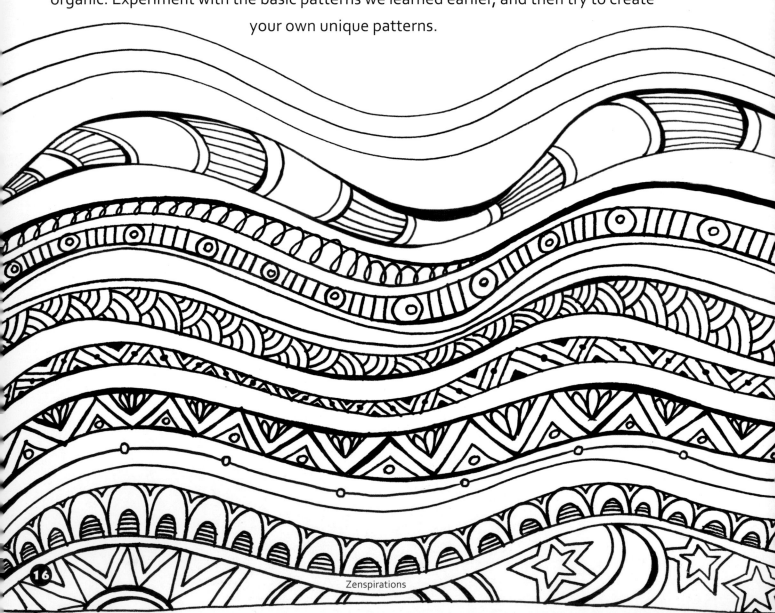

SIMPLE WAVE PATTERNS

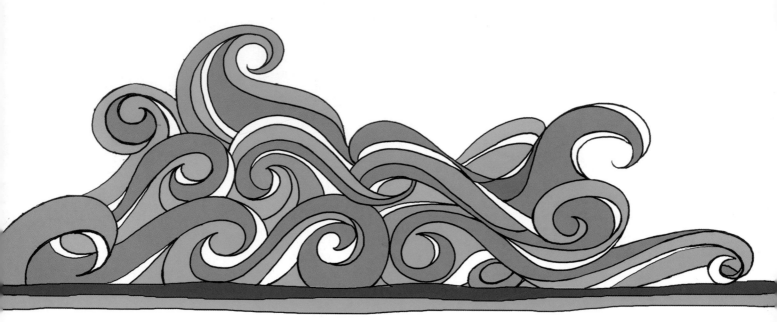

Elegant in their simplicity, the rounded shapes of these flowing waves form a beautiful, undulating pattern. As you'll notice in the example below, by adding pattern into the white spaces, the waves become more detailed and dramatic. To create rhythmic waves, start by drawing a wavy line and then spiraling one end inwards. Practice drawing wave shapes in a row, until creating waves feels comfortable and familiar to you. Then try drawing different size waves moving in different directions, like these examples. Add your favorite patterns to create your own unique wave design.

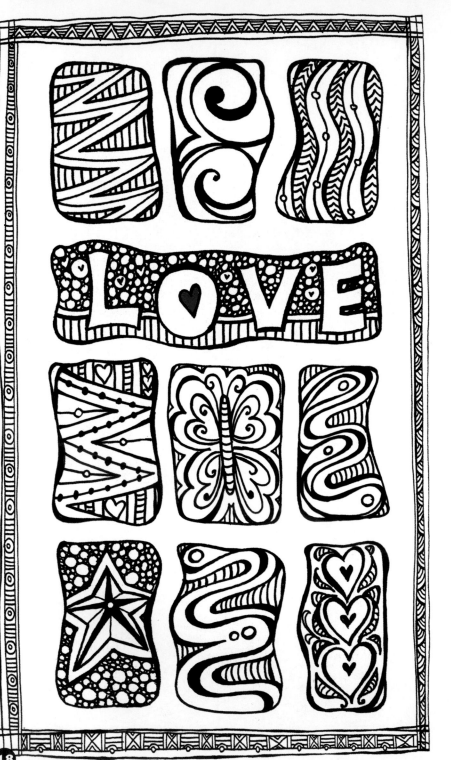

PATTERN BLOCKS

Reminiscent of Medieval block printing, filling open spaces with pattern blocks gives you the opportunity to create something wonderful and small in scale – and you can complete the design in no time at all!

Begin by drawing a row (or two or three) of rectangles with rounded corners. You'll get a more natural and cohesive appearance if the sides of your blocks echo the shape of the next block, which is easiest to achieve by drawing all of the blocks first before going back to add the interior patterns.

After you have your blocks drawn, divide the interior space either by drawing a shape inside the block, or subdividing the block into smaller areas. Then fill the spaces with your favorite patterns, as shown in the step by step examples on the next page.

STEP 1

STEP 2

STEP 3

STEP 4

STEP 5

COLORING TOOLS

Before investing in new supplies, try drawing and coloring your patterns with your favorite tools. If you haven't experimented with color before, ask a creative friend for advice or visit your local retailer to test different types of coloring tools.

My favorite pens are made by Sakura of America. I love their tools so much that I filmed a series of videos demonstrating pattern techniques using their awesome pens. You can find the videos on Sakura's website: www.sakuraofamerica.com, or look them up on YouTube. In the "Sakura Fanatic!" video I show how to use all the different types of pens they make... many of which are pictured on these two pages.

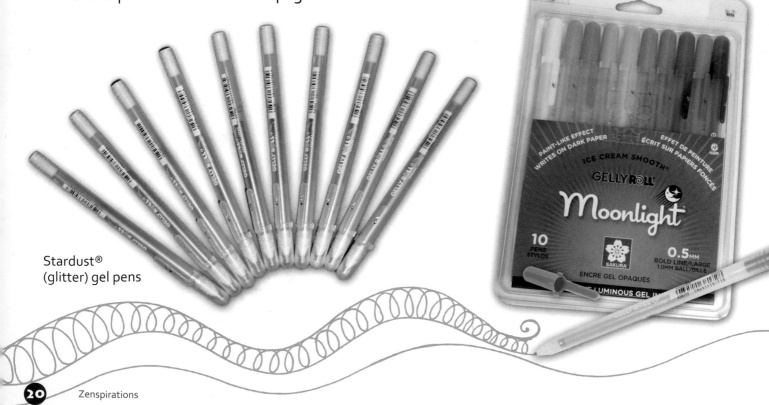

Gelly Roll Metallic® pens

Stardust®
(glitter) gel pens

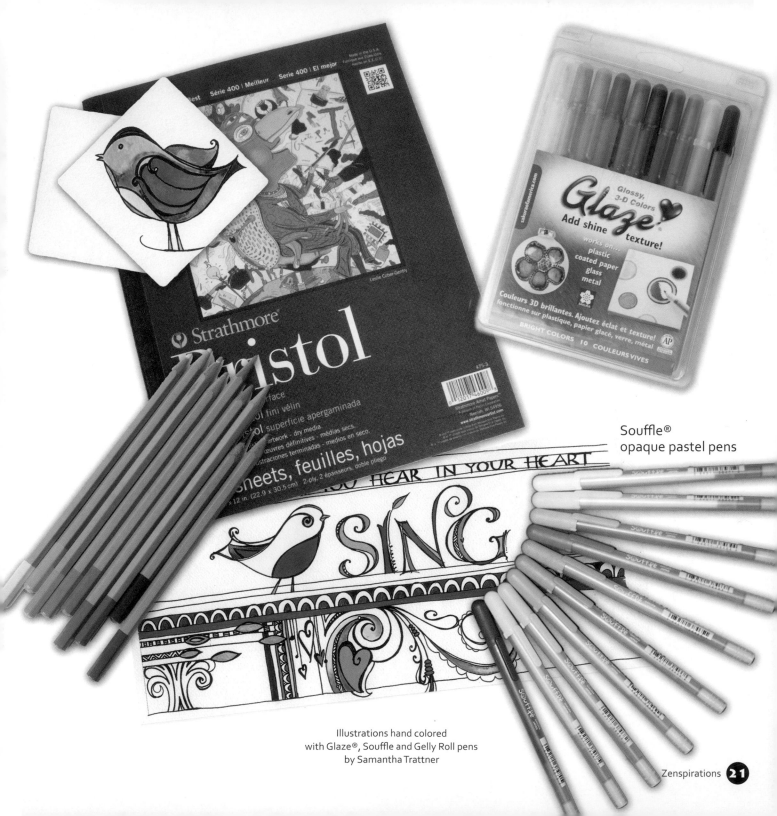

Souffle® opaque pastel pens

Illustrations hand colored
with Glaze®, Souffle and Gelly Roll pens
by Samantha Trattner

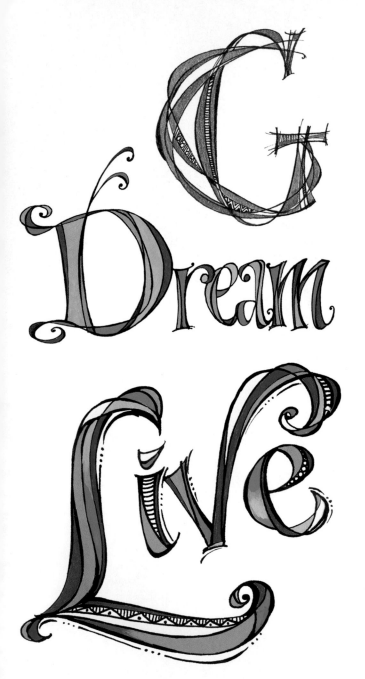

Pen Techniques for Dark & Light Backgrounds

To add color accents to my designs, I often use combinations of Sakura's Metallic and Stardust pens, as I did in the monogram "G". I wrote the words "Dream" and "Live" using a shiny black Glaze pen to create the outlines, and then filled the spaces with bright color Gelly Roll Moonlight® pens — the vivid neon colors work well on both light and dark papers.

On the right hand page I've doodled on Strathmore's wonderful black Artagain® paper with different Sakura pens. The "Dream" and "Sing" are done with the Metallic, the "Laugh" and "Dance" are done in Souffle (which in addition to being opaque will also write on plastic, metal, glass and other non-porous surfaces), the white "Live" and "Love" were done with a white gel pen, and I wrote the colorful "Play" and "Live" with Moonlight pens.

One of my favorite techniques to do on black paper is a tone-on-tone effect; contrasting the shiny black translucent Glaze ink with the soft matte paper. It's difficult to photograph but you can watch me demo this technique in the Sakura Fanatic video on YouTube. Try it — it's loads of fun, and I think you'll love the way it looks.

Like stars against a deep midnight sky, your words will sparkle when you apply a white pen to black paper.

DREAM

LIVE

Laugh

Dance

LIVE

LOVE

PLAY SING

WATERCOLOR TECHNIQUES

Watercolors allow you to create stunning effects that bring your drawings to life. In addition to a plentiful supply of water, you'll need paint, brushes and paper.

BRUSHES: You can't overestimate the importance of a really good brush. For most of my painting work I use a pointed brush. Although they are expensive, my absolute favorites for detail work are Winsor & Newton® series 7 sable brushes. For washes I use a flat brush; there are many good synthetic ones available. For convenience when I'm on the road, I often use a "water brush" with a hollow handle that stores water. I usually keep one (and the small watercolor set shown below) in my travel bag, which makes it easy to add a touch of paint to a project even if I'm on the road.

PAINT: Watercolors come in two forms: wet and dry. Wet watercolors are available in tubes; dry watercolors come in cakes or pans. Both types are mixed with water; the more water you use, the paler the color. Experiment blending different colors together to achieve your desired effect; I always keep a 'test sheet' handy, so I can put a little paint down and see how it looks before I tackle my design. It is important to work quickly when using watercolors, because once they dry it is much more difficult to blend them. When painting, work in one small area at a time, and keep the leading edge wet to avoid drying lines.

Sakura Koi® Watercolors and Koi® Water Brush

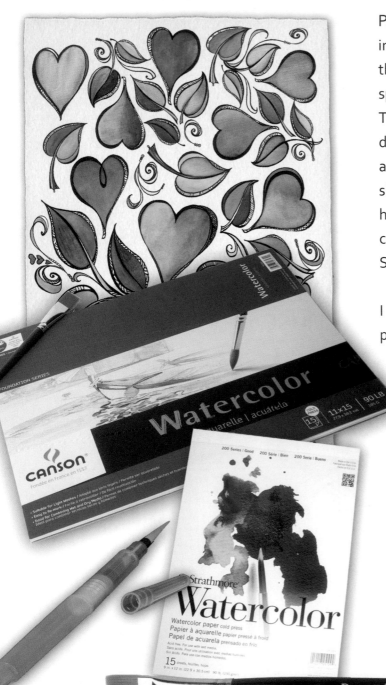

PAPER: Paper makes a huge difference in how your painting turns out; you'll get the best results by using a paper designed specifically for watercolor or wet media. These papers are usually available in three different finishes: hot-press, which has a smooth finish; cold-press, which has a slightly textured finish; and rough, which has an extremely textured finish. I like a cold-press paper like Strathmore's 400 Series (140lb) watercolor paper.

I prefer to draw on a relatively light weight paper which isn't suitable for watercolors, so when I want to hand paint one of my drawings I scan it, and print it onto 90 lb watercolor paper. The 90 lb stock works nicely in my laser printer, and the toner acts almost as a resist, which helps me stay inside the lines! I either use Canson's Foundation Series or Strathmore's 200 Series Watercolor paper. Try different brands and finishes to see what works best for you.

Watercolor painted by Samantha Trattner

SIMPLE FRAMES

Frames add a finishing touch to your designs. Next time you view a museum painting, notice the frame. You'll often find elaborate scrollwork or patterns which complement the central image. Surrounding a drawing with a beautiful frame tells the world that it is worthy of attention. Try to experiment with these easy-to-create frame enhancements. Start with two rectangles, one inside the other, then fill the space between the rectangles with patterns, illustrations or even words.

STEP 1	STEP 2	STEP 3	STEP 4

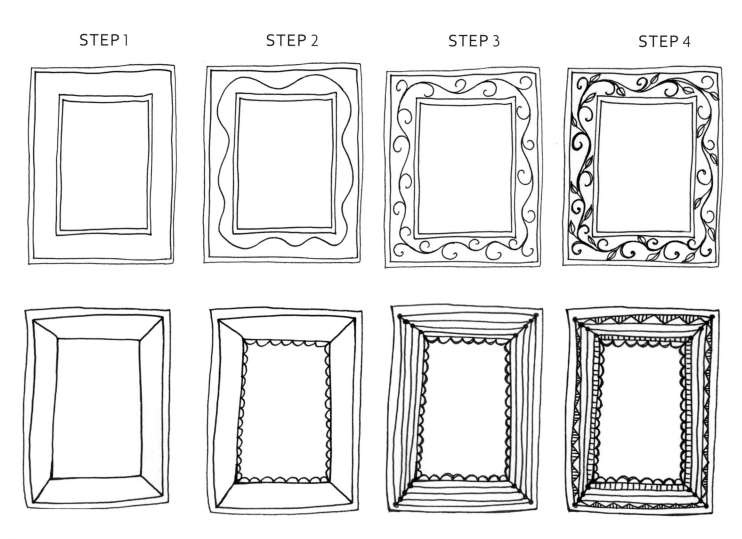

EASY FLOWER CORNER FRAME

STEP 1 Draw a simple flower outline in the corners, and an undulating wave in the border strips.

STEP 2: Double stroke the flower petals and waves.

STEP 3: Add weight and an interior line to the petals and a line pattern to the inside curve of the border strips.

STEP 4: Add circles as a finishing touch to the flowers and the border strips.

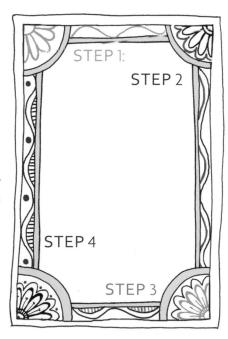

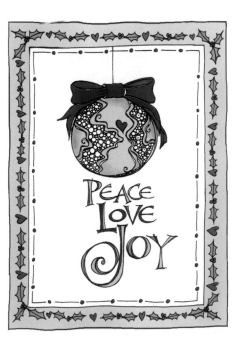

EMBELLISHED FRAMES

Once you have mastered drawing simple frames, you can attempt creating more complex ones. Keep in mind that the frame should enhance, not detract from, your art. It's fun to add color to your frames. I'll often try several different color combinations before settling on the one I want.

PLANT
SEEDS
OF LOVE

The four sides of this frame show different ways of using color inside small consecutive blocks. The top and left borders have alternating colorful and white spaces; the bottom and right borders have the color bars touching each other. Experiment with other variations of this pattern.

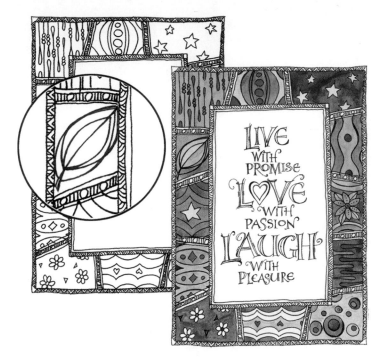

LIVE
WITH
PROMISE
L♥VE
WITH
PASSION
LAUGH
WITH
PLEASURE

Creating Patterned Illustrations

STEP 1 Draw a simple heart shape.

STEP 2 Add spaces around the edges by double stroking the heart.

STEP 3 Fill the spaces with patterns.

STEP 4 Add your own special finishing touches!

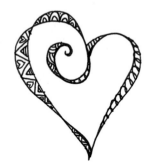

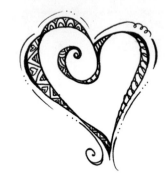

Use these simple step-by-step instructions to enhance your line drawings. Remember – patterning is cumulative – the more patterns you add, the more detailed your design will become. Once you have tried these designs, experiment with other shapes. Nature is always a good resource – look at your favorite birds, leaves, flowers and animals for inspiration.

Color Options

A: Color the patterns.

B: Color the interior.

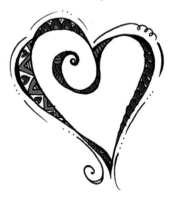

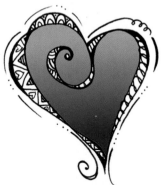

STEP 1
Draw a simple cross

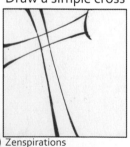

STEP 2
Add an outline

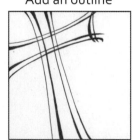

STEP 3
Fill with pattern

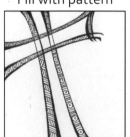

STEP 4
Add another outline

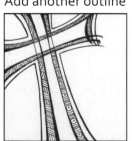

STEP 5
Finish with color

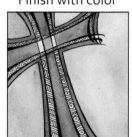

BEAUTIFUL BUTTERFLIES

One of the most useful things about the Zenspirations patterning technique I've developed is that it actually lets me adjust my illustrations and fix mistakes while I am working. For example, on the butterfly in step one, you'll notice that the lower left wing is smaller than the lower right wing, but on the other examples the wings are the same size. This is because I was able to balance the wings by double stroking the outside edge of the left wing, and the inside edge of the right wing.

STEP 1 Draw a simple butterfly shape.

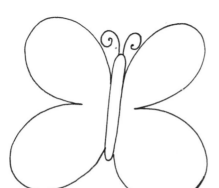

STEP 2 Double stroke the butterfly to create open spaces around the edge of the drawing.

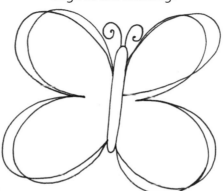

STEP 3 Fill the spaces with pattern.

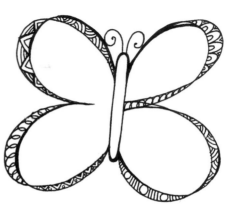

STEP 4 Decorate the open wing area and body, and then add a dotted butterfly trail as a finishing touch.

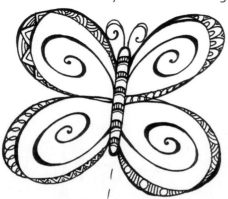

COLOR OPTIONS

A: Color the patterns.

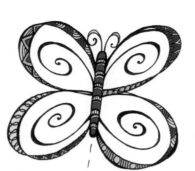

B: Color the interior.

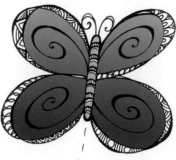

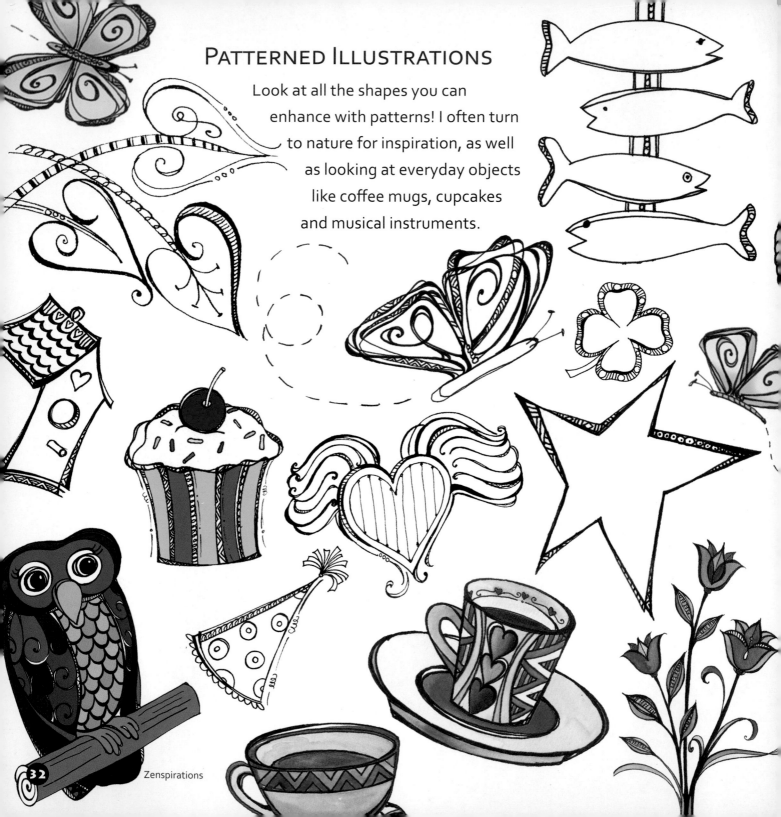

Patterned Illustrations

Look at all the shapes you can enhance with patterns! I often turn to nature for inspiration, as well as looking at everyday objects like coffee mugs, cupcakes and musical instruments.

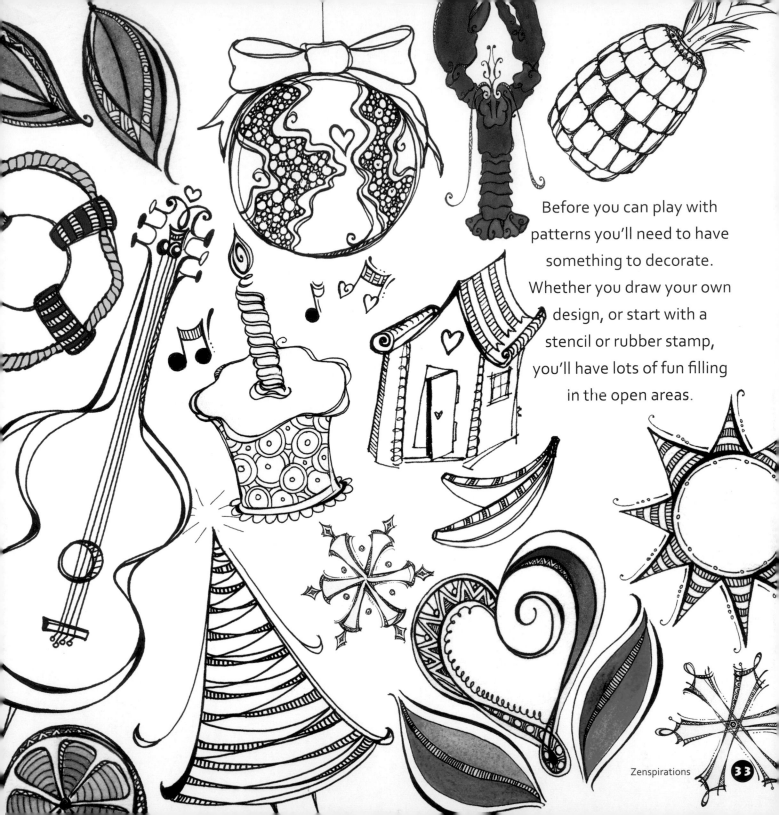

Before you can play with patterns you'll need to have something to decorate. Whether you draw your own design, or start with a stencil or rubber stamp, you'll have lots of fun filling in the open areas.

EASY FLOWER & LEAF DESIGNS

I love to draw patterned flowers and leaves! Below are some of my favorites; notice that the left and right hand sides of each stem feature variations of the same leaf. Use these examples – or look in your own garden – for inspiration.

On the left I've drawn two common leaf shapes: almond and heart. Notice how different they look when they are drawn at different sizes and angles. Draw these basic shapes or create your own leaf designs.

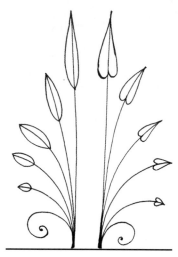

Almond shaped leaves Heart shaped leaves

On pages 14 and 15 we looked at easy ways of drawing flowers viewed full on; here are some examples of simple blossoms drawn from the side view. Mix and match petals, flowers, stems and leaves to create your own unique designs.

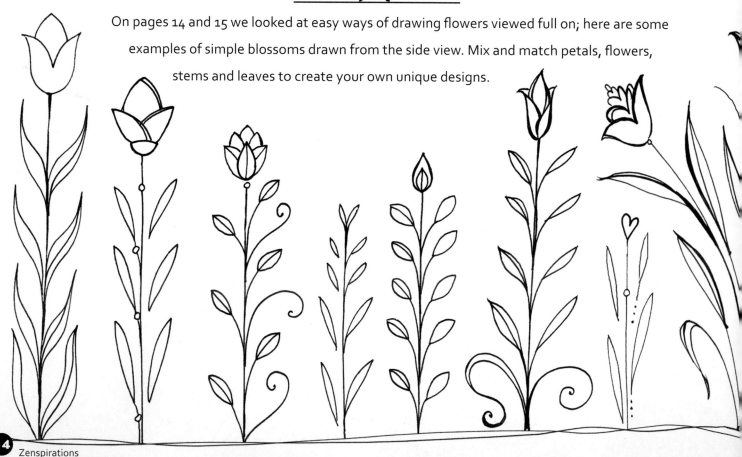

SIMPLE LANDSCAPES

STEP 1	STEP 2	STEP 3	STEP 4	STEP 5

 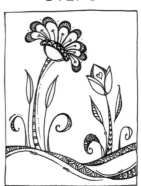

STEP 6

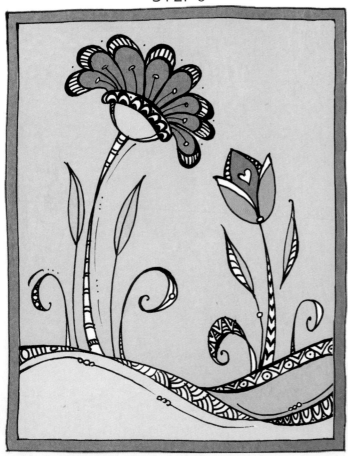

STEP 1: Draw hills, stems and leaves.

STEP 2: Draw flower petals.

STEP 3: Add a space around the edges of the flowers, hills and leaves by double-stroking inside or outside the first line.

STEP 4: Add your favorite patterns into the spaces.

STEP 5: Add finishing touches, like hairlines and extra weight, to the edges of the shapes.

STEP 6: Add a frame and then color your landscape in your favorite hues.

CREATE YOUR OWN
FLOWER GARDEN

To create your very own flower garden start by doodling simple stems, leaves and flower shapes. Use all your favorite flowers – it doesn't matter if they would all bloom at the same time of year. Create a flower garden that you can enjoy all year long! Add your own special touches – I've included butterflies and dragonflies in mine, but you might prefer birds and birdhouses. The only limit is your imagination...

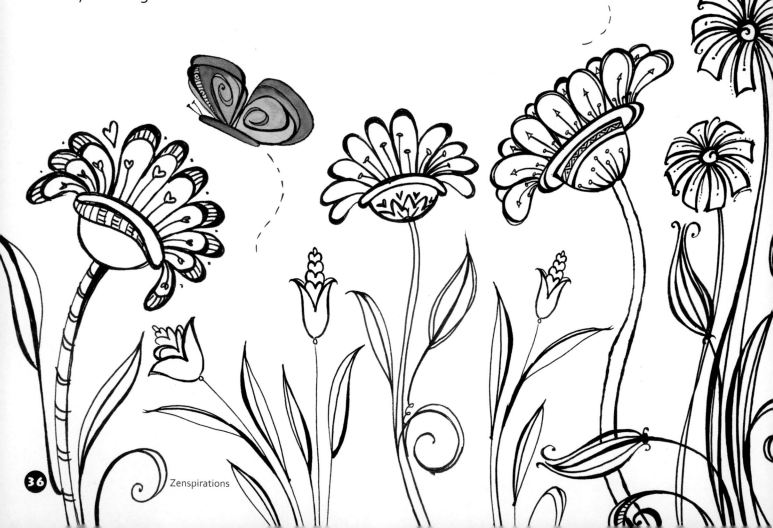

Zenspirations

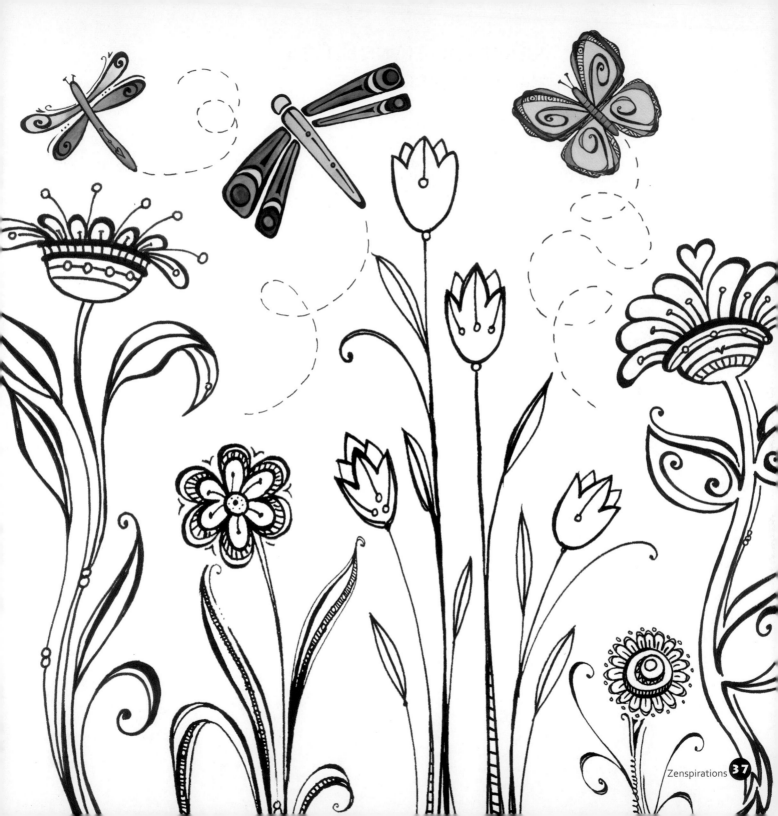

Zenspirations Built Up Capitals

These simple letterforms work well if you are looking for a style that won't compete with your patterning. I use a Micron® size 01 to draw them... although they are drawn with a monoline tool, I add weight in order to give the letters a calligraphic flair. This alphabet is supposed to be funky, so don't try to make the letters too perfect. When I am writing them in a word or sentence, I try to 'bounce' them a bit rather than keeping them straight – it adds interest to my work.

STEP 1 A B C D E F G

STEP 2 A B C D E F G

STEP 3 A B C D E F G

STEP 4 A B C D E F G

STEP 1 O P Q R R S T

STEP 2 O P Q R R S T

STEP 3 O P Q R R S T

STEP 4 O P Q R R S T

STEP 1: Draw the basic shape of the letter; I call this the 'skeletal letterform'.

STEP 2: Starting from the first point you drew, draw another stroke that is angled a few degrees wider than your first one.

STEP 3: Close the edges of any strokes which did not meet. The result will be a 'hollow' letterform.

STEP 4: Fill the letterform in so it is all black (or whatever color you want it to be).

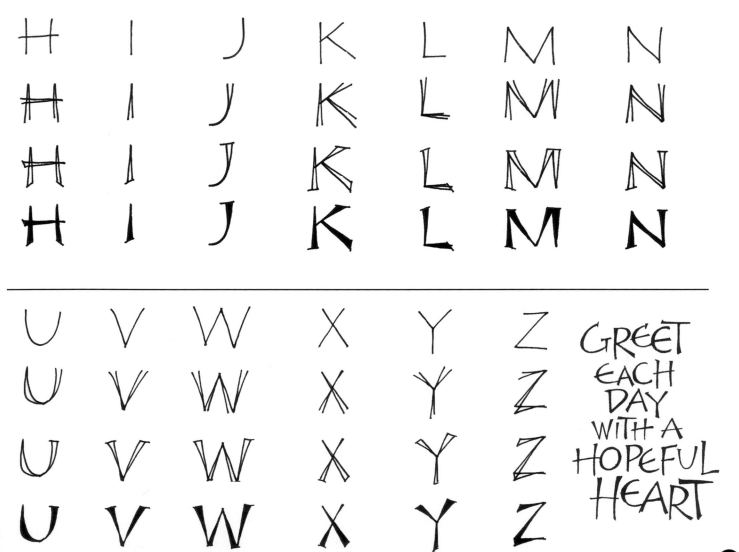

GREET
EACH
DAY
WITH A
HOPEFUL
HEART

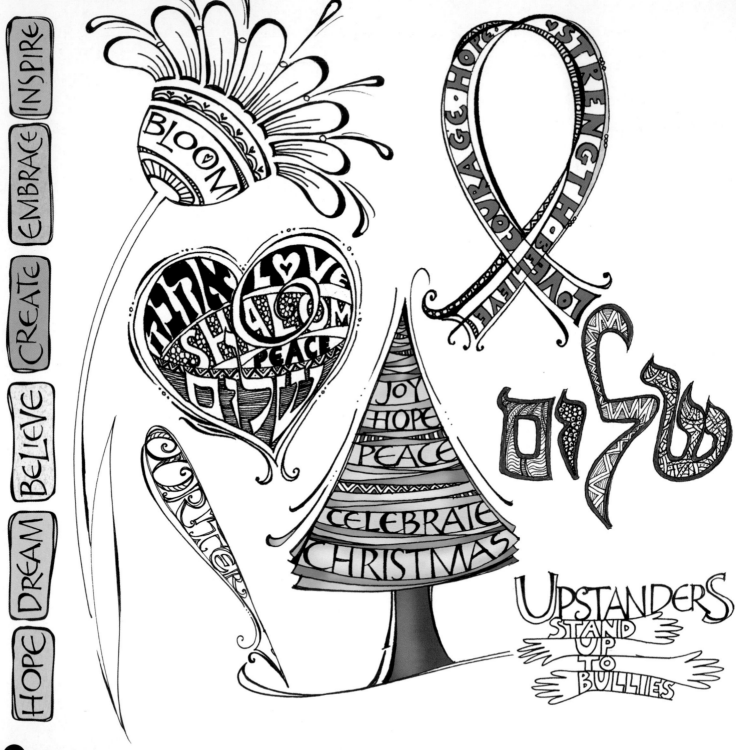

INSPIRE
EMBRACE
CREATE
BELIEVE
DREAM
HOPE

BLOOM

LOVE
SHALOM
PEACE

WRITER

JOY
HOPE
PEACE
CELEBRATE
CHRISTMAS

HOPE · STRENGTH
COURAGE · BELIEVE · LOVE

שלום

UPSTANDERS
STAND
UP
TO
BULLIES

WORDS IN SHAPES

As both a writer and a lettering artist I use words as my medium... and I am delighted to share my love of letters and text through my design work. Words have transformative powers... meaningful messages truly touch people's hearts. As an inspirational writer, I always look for ways of incorporating uplifting words and phrases into my work; the playful word flowers on this page are a good example. I also enjoy creating word blocks, like the ones below, where the letters create rhythm and texture just the way repetitive geometric lines do. I'd encourage you to experiment using text as a decorative element — and as a way of sharing your thoughts and ideas as well.

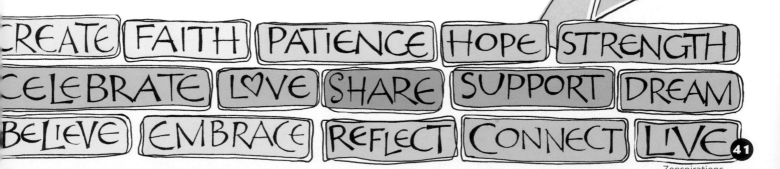

Zenspirations

PATTERNED MONOGRAMS

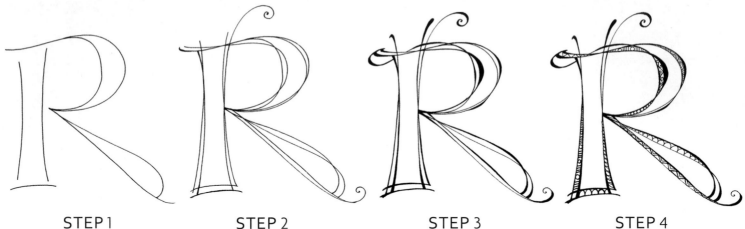

STEP 1
Draw outline of letter.

STEP 2
Double stroke the outline and close the edges.

STEP 3
Add weight to the strokes to help ground the letter.

STEP 4
Fill the spaces around the letter's edge with pattern.

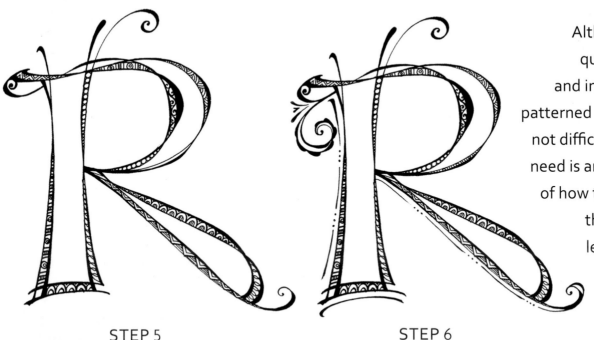

STEP 5
Embellish the patterns.

STEP 6
Add your own special finishing touches.

Although they look quite complicated and impressive, these patterned monograms are not difficult to do; all you need is an understanding of how to double stroke the edges of your letterform to add space, and then fill that space with pattern.

Monogram Variations

Monograms make great personalized gifts – who doesn't like to see their name or initial drawn in a unique and special way? I often incorporate the recipient's favorite colors into the design. There are so many different ways to add pattern and color – as an experiment try drawing and coloring the same letter three different ways; you'll be amazed by the results!

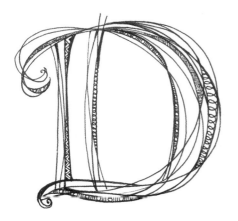

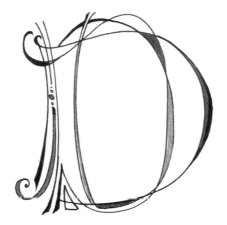

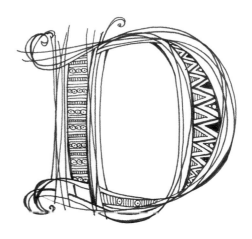

EXAMPLE A
This example uses 'classic' Zenspirations style with the patterning placed in the spaces around the perimeter of the letter.

EXAMPLE B
This "D" shows the spaces around the perimeter of the letter filled with color instead of pattern, which gives a clean, contemporary look.

EXAMPLE C
For this third example I drew the patterning on the large interior spaces rather than in the small exterior spaces, which gives the letter a dramatically different appearance.

No matter how many times you draw the same letter, it will never turn out exactly the same way twice – even if that is your goal. But rather than striving to create the same style monogram over and over, I often try to develop new styles that I can build into an entire alphabet. Sometimes I look at old manuscripts for inspiration. Medieval scribes were experts when it came to decorated letters. Study illuminated Books of Hours; they provide an endless inspiration for pattern and letterforms. Books of old fairy tales are also good sources of inspiration as they often begin with beautiful decorated letters. Most of all, don't be afraid to experiment and have fun!

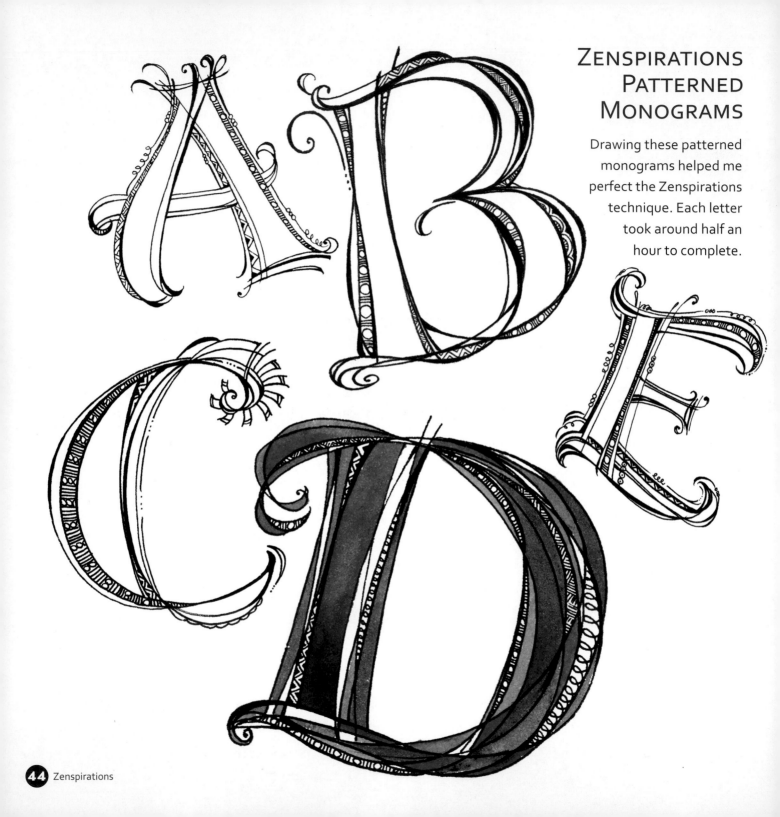

ZENSPIRATIONS PATTERNED MONOGRAMS

Drawing these patterned monograms helped me perfect the Zenspirations technique. Each letter took around half an hour to complete.

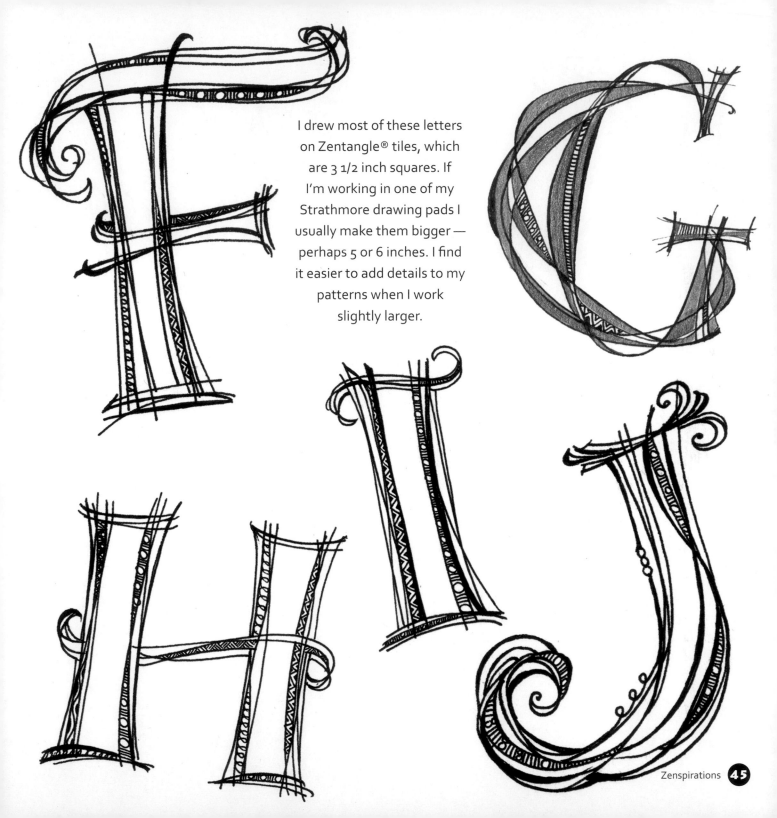

I drew most of these letters on Zentangle® tiles, which are 3 1/2 inch squares. If I'm working in one of my Strathmore drawing pads I usually make them bigger — perhaps 5 or 6 inches. I find it easier to add details to my patterns when I work slightly larger.

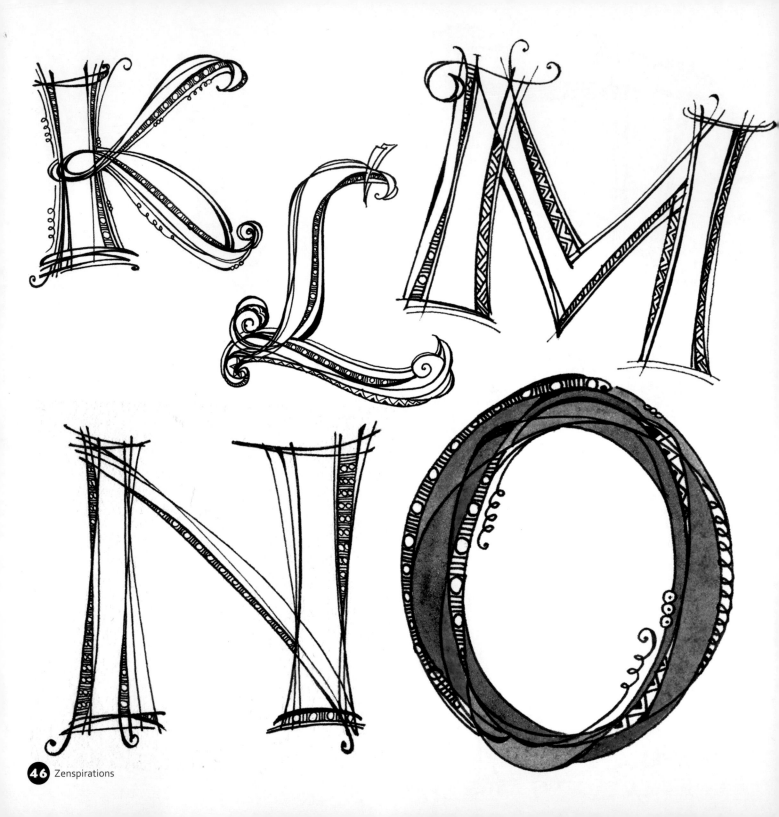

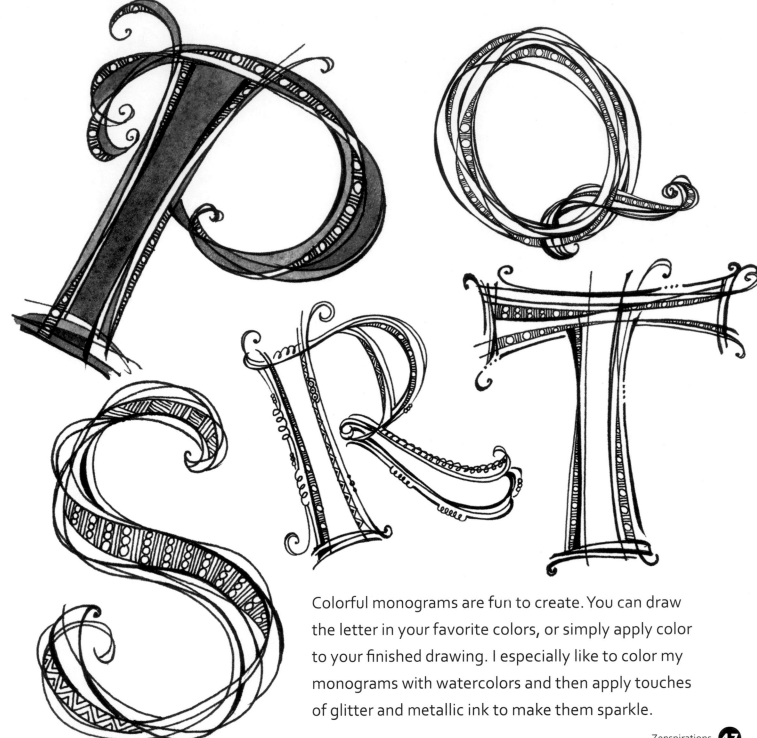

Colorful monograms are fun to create. You can draw the letter in your favorite colors, or simply apply color to your finished drawing. I especially like to color my monograms with watercolors and then apply touches of glitter and metallic ink to make them sparkle.

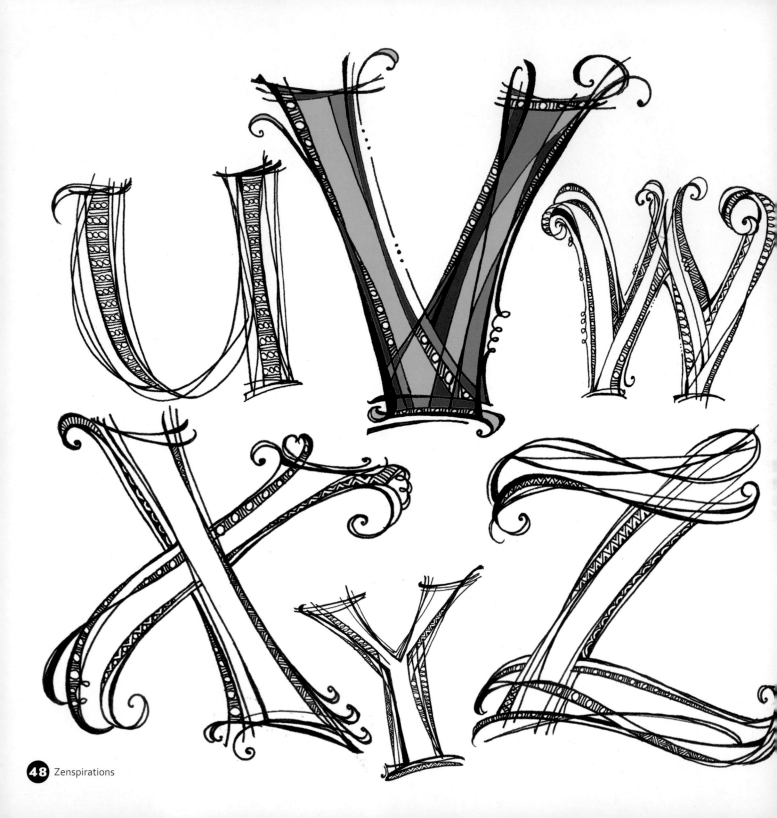

Acknowledgements

As you may know by now, I am passionate about patterning... and feel so blessed to have embarked upon this amazing adventure. I hope I have inspired you to play with patterns too... and I'd love to see what you do with them! If you'd like to share your work, please e-mail jpegs or pdfs to me at joanne@zenspirations.com. In addition to sharing the Zenspirations patterning techniques with you, I'd also like to share some of the things I do with my finished designs. On the next two pages you'll find photos of different products I've licensed which feature my patterning techniques. They are marketed under the "Inspired Journey" brand, and I invite you to use patterning to help make your life an inspired journey, too.

My creative journey has been deeply enriched by my colleagues, students, friends and family who have continually inspired and enlightened me; thank you all for being a part of my life. Special thanks to Rick and Maria for introducing Zentangle to the world, and to Brenda Broadbent of Paper & Ink Arts for introducing me to Zentangle! Thank you to my children, Samantha and Jonathan Trattner, who tried the exercises to make sure the instructions were understandable. My deepest appreciation to the wonderful folks at Sakura, who not only manufacture my favorite pens, but introduced me to Suzanne McNeill at Design Originals. Working with Suzanne on this book has been a delightful experience. Very special thanks to Heather Brown, graphic designer extraordinaire, whose talent and keen eye have helped Zenspirations and Inspired Journey evolve into this amazing adventure. And lastly, heartfelt thanks to my husband, Andy Trattner, for his sense of humor, indispensable technical assistance, and his patience with my lifelong fascination with letterforms and my newfound passion for patterning.

JOANNE FINK LOVES LETTERS, WORDS AND WRITING INSPIRING SENTIMENTS. AFTER SPENDING OVER TWO DECADES AS AN ART DIRECTOR, SHE IS ENJOYING BEING BACK AT THE DRAWING BOARD, EXPLORING NEW DIRECTIONS IN HER ARTISTIC AND CREATIVE JOURNEY. A GIFTED CALLIGRAPHER AND DESIGNER, JOANNE WORKS OUT OF HER LAKE MARY, FL STUDIO, LAKESIDE DESIGN, DEVELOPING PRODUCTS FOR THE GIFT, CRAFT AND STATIONERY MARKETS. FOR MORE INFORMATION ABOUT JOANNE AND HER WORK, VISIT HER WEBSITE: WWW.LAKESIDE-DESIGN.COM.

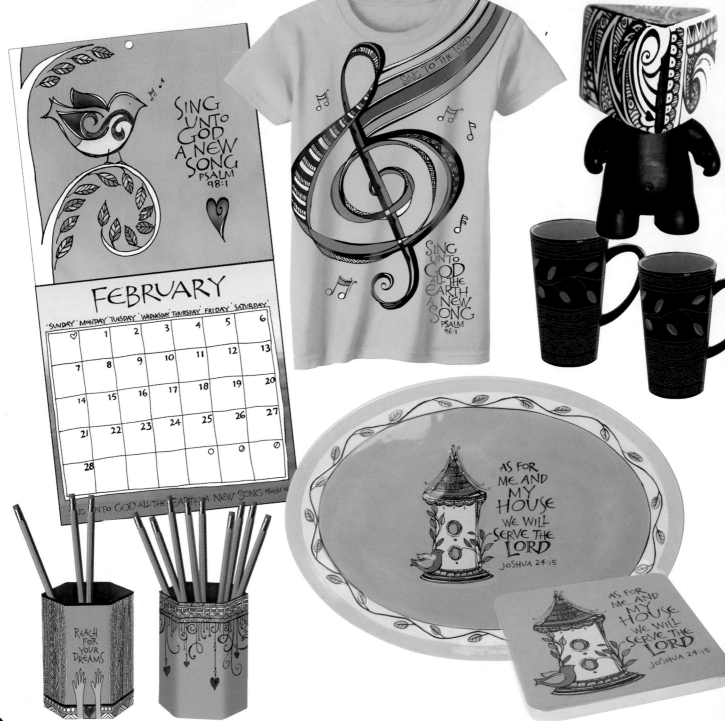

SING UNTO GOD A NEW SONG PSALM 98:1

FEBRUARY

SUNDAY	MONDAY	TUESDAY	WEDNESDAY	THURSDAY	FRIDAY	SATURDAY
♡	1	2	3	4	5	6
7	8	9	10	11	12	13
14	15	16	17	18	19	20
21	22	23	24	25	26	27
28						

SING UNTO GOD ALL THE EARTH A NEW SONG PSALM 96

SING TO THE LORD

SING UNTO GOD ALL THE EARTH A NEW SONG PSALM 96:1

REACH FOR YOUR DREAMS

AS FOR ME AND MY HOUSE WE WILL SERVE THE LORD JOSHUA 24:15

AS FOR ME AND MY HOUSE WE WILL SERVE THE LORD JOSHUA 24:15